THIS BOOK BELONGS TO

Garden Hearts

Felder Rushing

st. lynn's
press

PITTSBURGH

Garden Hearts

ISBN-13: 978-0-9832726-3-2

Library of Congress Control Number: 2011944663
CIP information available upon request

First Edition, 2012

St. Lynn's Press · POB 18680 · Pittsburgh, PA 15236
412.466.0790 · www.stlynnspress.com

Book design – Holly Rosborough, Network Printing Services
Editor – Catherine Dees

Photographs © Felder Rushing

Printed in The United States of America

This title and all of St. Lynn's Press books may be purchased for educational, business, or sales promotional use. For information please write:
Special Markets Department · St. Lynn's Press · POB 18680 · Pittsburgh, PA 15236

10 9 8 7 6 5 4 3 2 1

A beautiful Garden is a work of Heart!

HISTORY OF THE HEART SHAPE

*"We picture love as heart-shaped because
we do not know the shape of the soul."*

- ROBERT BRAULT

I am a lover of the heart shape. Always have been. As a teenager, I cut them out of rubber bicycle tire inner tubes and glued them to the tips of my tennis shoes. Now a grownup (more or less) and a garden photographer, I'm still in love with the heart shape.

While visiting countless gardens across five continents and every state in the U.S., I have had the evocative symbols appear suddenly – unsought, as if they were tugging at my heartstrings to be noticed. I don't even have to look for them; they find me.

A bit of history: Though the origins of this unique icon are lost in antiquity, the symbol has been around a long, long time. The heart shape can be defined by mathematical equations or simply formed between your hands, using thumbs and index fingers. It first appeared in pictograms of pre-Ice Age Cro-Magnon hunters and on ancient coins dating to the seventh century B.C., as well as adorning pottery made over 5,000 years ago. And it's associated with both Eros, the Greek god of love, and Cupid, his Roman counterpart.

The heart symbol has long been used to refer to our emotional, spiritual, and moral core, and even to the soul. In the Middle Ages, the heart sign was linked to both spiritual and physical love, and became a major symbol for heraldry, where it signified sincerity and clarity. In Buddhism, the auspicious shape symbolizes enlightenment, and it has also appeared with religious or positive meanings among Aztecs, Hindus, Muslims, Jews, Celts, and Taoists. It is a universally good thing.

In the fifteenth century it started showing up on playing cards. In an infamous card game in 1688, one of England's best known haunted castles, Levens Hall (home of perhaps the world's best ancient topiary garden), was gambled away on a single card – the ace of hearts. To this day its gates, fences, and even its lead rain spouts are ornamented with hearts.

The heart quickly became a cultural mainstay, culminating in the universal Victorian-era St. Valentine's Day cards we now use to show affection, romance and loyalty. But while humans have been finding

ways to speak of hearts and love in the same breath, Nature has been speaking to us with heart shapes all along.

In my garden wanderings, I have discovered many plants with naturally heart-shaped leaves and flowers. I have also found heart shapes painted on walls, cut into fences, fashioned in gates, made out of bent metal, formed from daffodil beds, and created from pebbles, seashells, glass, and pottery bits impressed into concrete. There's even a cool blue stained glass heart overlooking the grave of Elvis.

Now hearts are everywhere, sometimes all but over-commercialized in promotions of products, pets, and places. Yet of all the places it appears, the heart seems to me most perfectly at home in the garden. Out of the thousands of "garden hearts" I have met and photographed, I have selected just a few of my favorites for this little book, along with bits of poetry and quotes that have meant a lot to me in my own garden – and a few words with each photo about where the happy encounter took place.

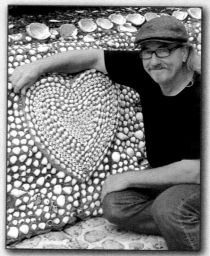

Seashell bench, Isle of Jersey, off the coast of France

Yours,

Felder Rushing

Green is the prime color
of the world,
and that from which
its loveliness arises.

PEDRO CALDERÓN DE LA BARCA

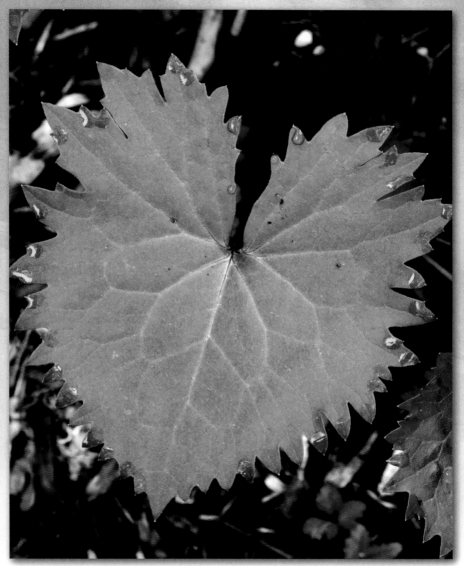

Forest in the Bavarian Alps

People from
a planet
without flowers
would think
we must
be mad
with joy
the whole time
to have
such things
about us.

IRIS MURDOCH

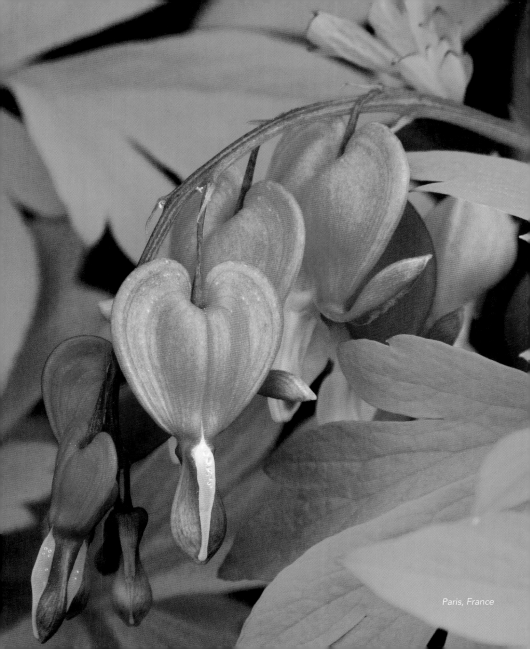

Paris, France

Love is a fruit
in season
at all times
and within
reach of
every hand.

MOTHER TERESA

slice from an orange

So if you'll permit,
a little advice from two
who have felt passion's sting:
if you invite art into the garden,
be prepared for a lesson on love.
It seems only right that
we learn love's lessons here;
relationship is so evident in a garden...

So go ahead,
invite art into the garden,
but go thoughtfully,
prayerfully even, and
stay firmly rooted in the divine,
for you are treading
on passionate ground.

SPRING GILLARD

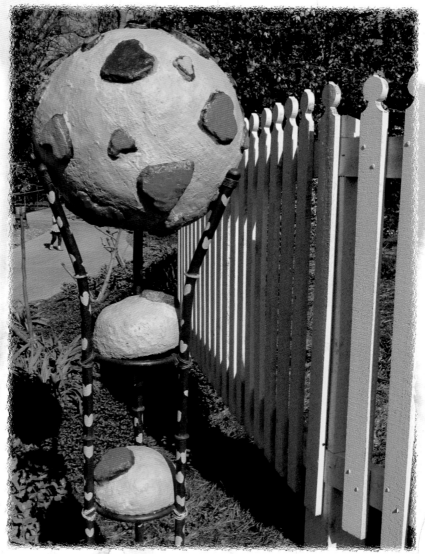

Memphis, Tennessee Botanical Garden

The heart must have
its time of snow . . .
to rest in silence,
and then to grow.

UNKNOWN

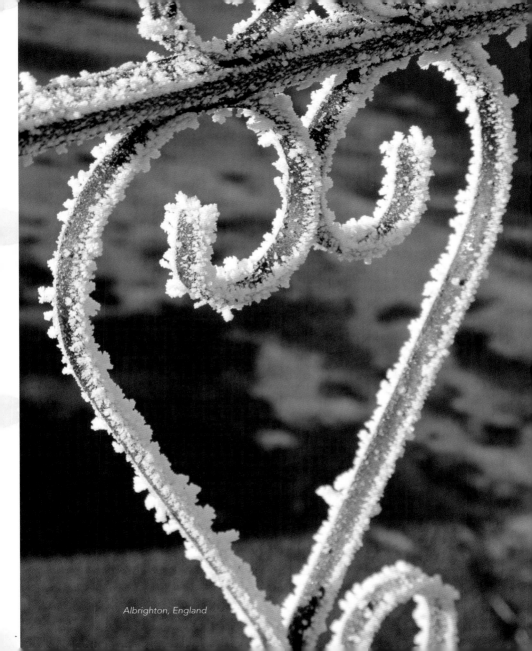
Albrighton, England

If I had a single flower

for every time

I think about you,

I could walk forever

in my garden.

CLAUDIA GHANDI

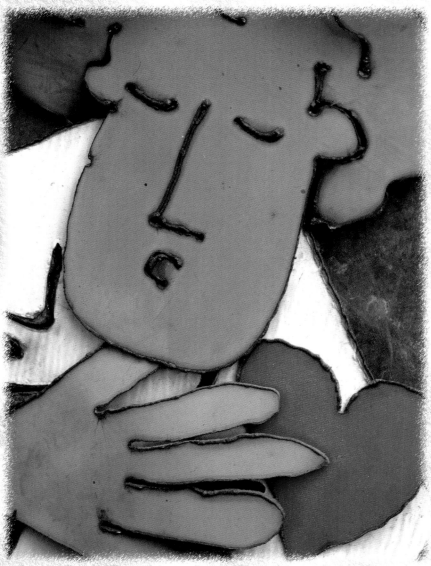

Central Vermont garden detail

There are many tired gardeners
 but I've seldom met old gardeners.

I know many elderly gardeners
 but the majority are young at heart.
Gardening simply does not allow
 one to be mentally old, because
too many hopes and dreams are
 yet to be realized.
Regardless of how bad past gardens
 have been, every gardener believes that
next year's will be better.

ALLAN ARMITAGE

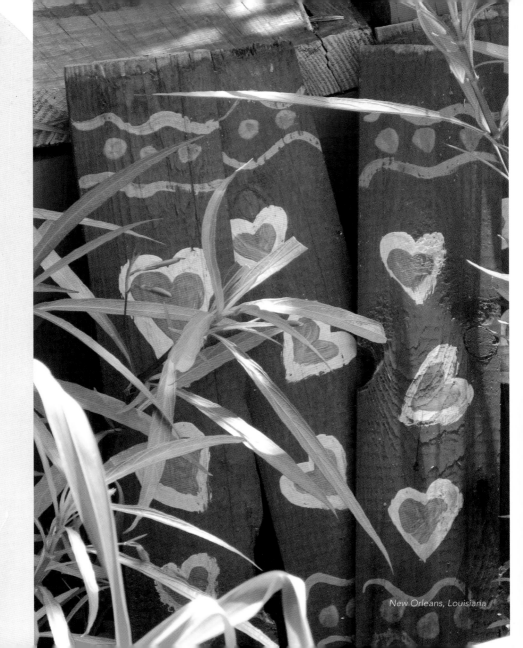

New Orleans, Louisiana

LET NO ONE THINK THAT
real gardening is a bucolic
and meditative occupation.

IT IS AN INSATIABLE PASSION,
like everything else to
which a man gives his heart.

KAREL ČAPEK

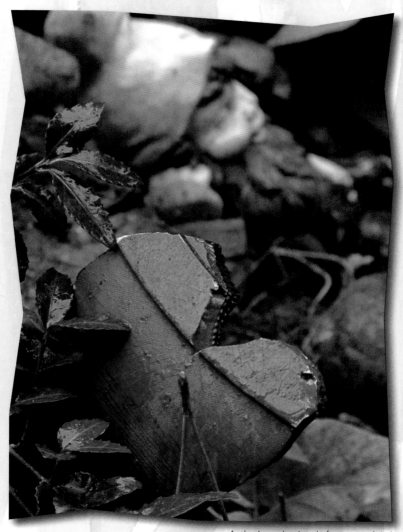

Author's garden (made from a used tire)

All paths
lead nowhere,
so it is important
to choose a path
that has **heart**.

CARLOS CASTANEDA

Wherever you go,
go with all your heart.

CONFUCIUS

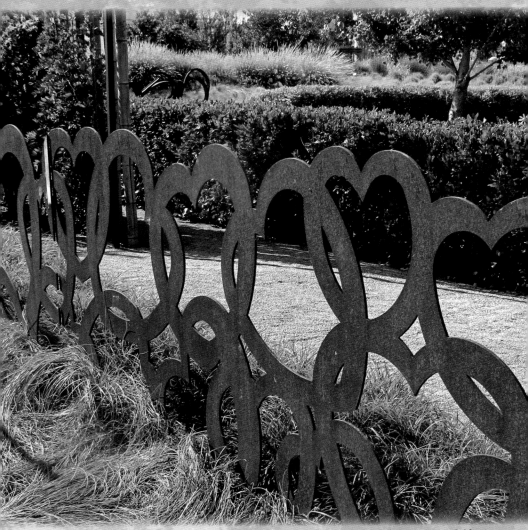

Art Garden near Napa, California

There is nothing in a caterpillar
that tells you it's going to be a butterfly.

R. BUCKMINSTER FULLER

'Just living is not enough', said the butterfly.
'One must have sunshine, freedom, and a little flower.'

HANS CHRISTIAN ANDERSEN

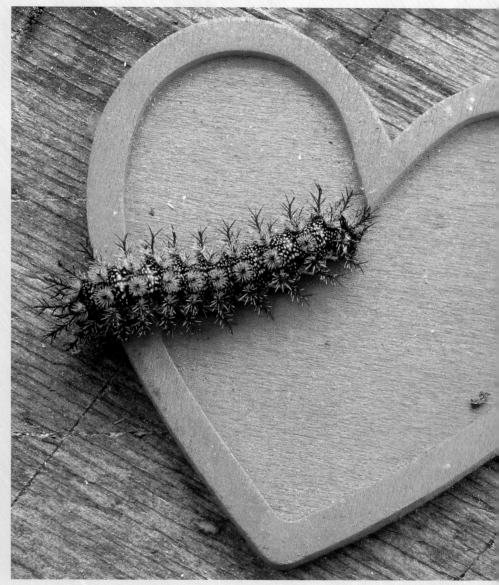

Austin, Texas

When a man's an empty kettle
he should be on his mettle,
And yet I'm torn apart.

Just because I'm presumin'
that I could be kind-a-human,
If I only had a heart.

I'd be tender — I'd be gentle
and awful sentimental
Regarding Love and Art.

I'd be friends with the sparrows ...
and the boys who shoots the arrows
If I only had a heart.

THE TIN MAN, WIZARD OF OZ

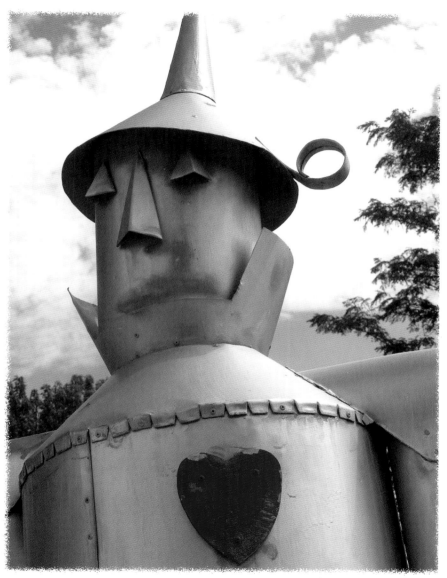

Wizard of Oz Museum, Liberal, Kansas

> *There are always flowers*
> *for those who want to see them.*

HENRI MATISSE

In the 1930s, when my great-grandmother Pearl came unexpectedly into several hundred dollars (a great deal of money during the Great Depression), she spent every penny on…daffodil bulbs.
Nearly 80 years later, as I dug, divided and shared some of the survivors with my children I thought about how for decades to come their spring fragrance will be an inheritance of love from their great-great-grandmother's hand and garden.

FELDER RUSHING

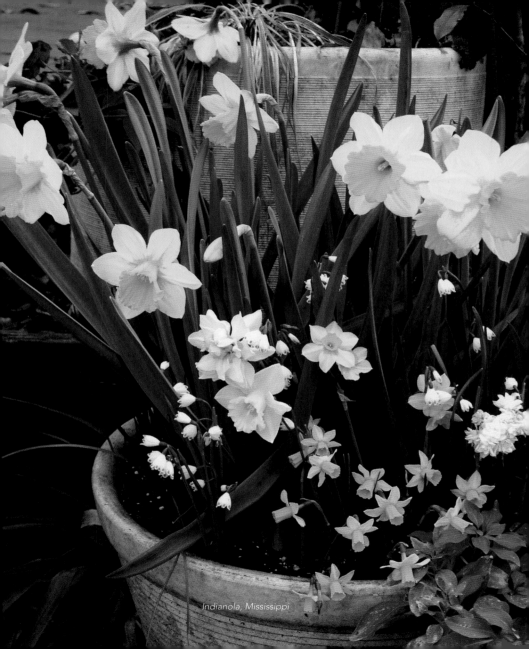
Indianola, Mississippi

Who loves a garden

　　　still his Eden keeps.

AMOS BRONSON ALCOTT

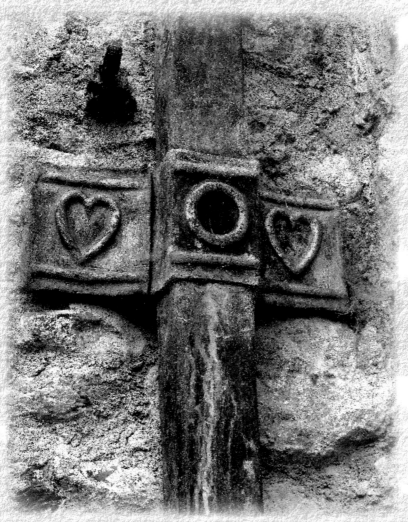

Levens Hall, northern England

THE WAY IS NOT IN THE SKY.
THE WAY IS IN THE **HEART**.

BUDDHA

JAPANESE FOR "SHAPE OF A HEART":
ハートマーク

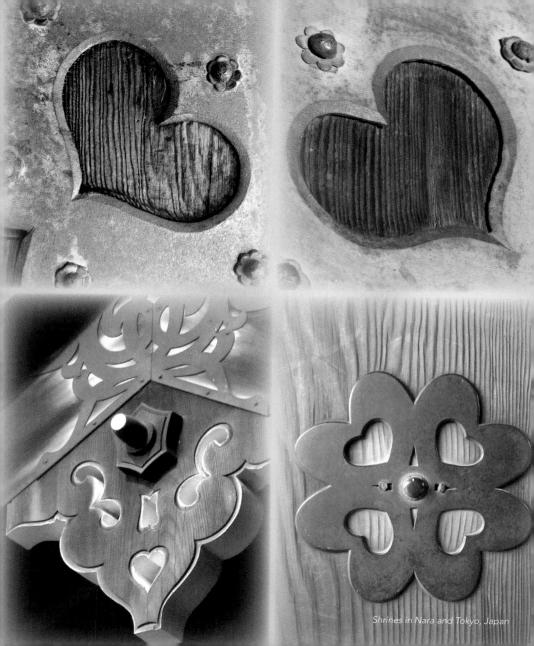

Shrines in Nara and Tokyo, Japan

The beauty of the world, which is

so soon to perish, has two edges,

one of laughter, one of anguish,

cutting the heart asunder.

VIRGINIA WOOLF

**El corazon de la auyama
solo lo conoce el cuchillo.**

*(The heart of a pumpkin – or edible squash –
is only known by the knife.)*

UNKNOWN

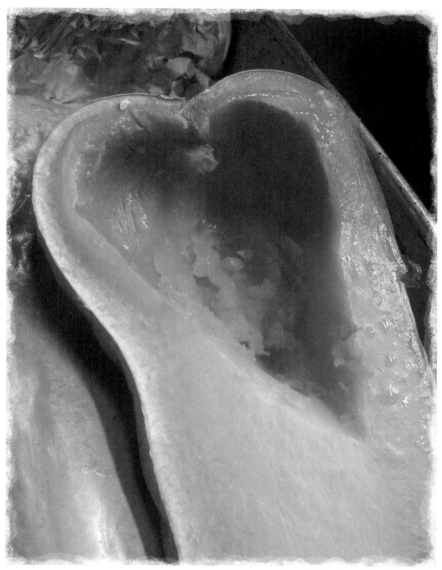

farm kitchen in rural New Hampsthire

If the sight of the blue skies fills you with joy, if a blade of grass springing up in the fields has power to move you, if the simple things of nature have a message that you understand, rejoice, for your soul is *alive.*

ELEONORA DUSE

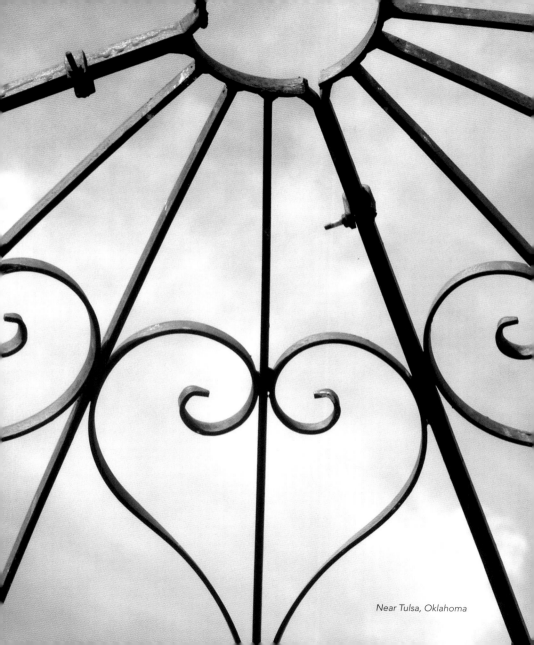

Near Tulsa, Oklahoma

Find the seed at

the bottom of your heart

and bring forth

a flower.

SHIGENORI KAMEOKA

The love of gardening
is a seed that once sown
never dies.

GERTRUDE JEKYLL

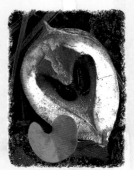

*Woodland edge in
Tacoma, Washington*

Will you love me in December
as you do in May,

Will you love me
in the good old fashioned way?

When my hair has
all turned gray,

Will you kiss me
then and say,

That you love me in December
as you do in May?

JAMES J. WALKER

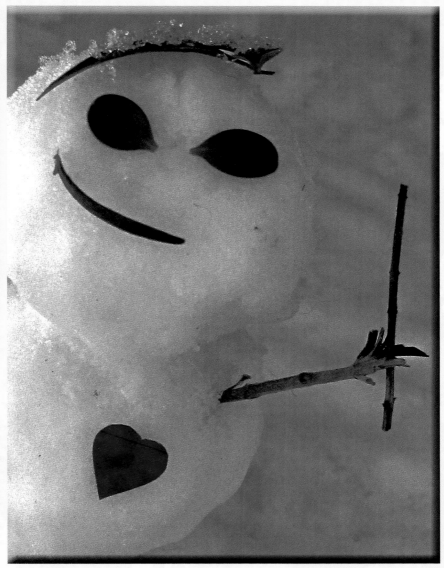

Jackson, Mississippi

I really love this garden of mine.
I even love it when it's cold and
muddy and being cantankerous.

I love it real good. I might
especially love it then. It's easy
to love when things are going
well and everything is balmy
and calm and productive.

Get out there and show some
love when things are dirty
and uncomfortable.

You'll be glad you did.

ELLABERRY GARDENS FEBRUARY 2011 NEWSLETTER

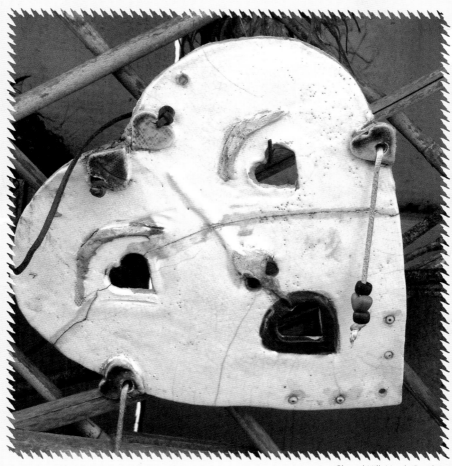

near Chapel Hill, North Carolina

Keep love in your heart.
A life without it is like
a sunless garden
when the flowers are dead.

OSCAR WILDE

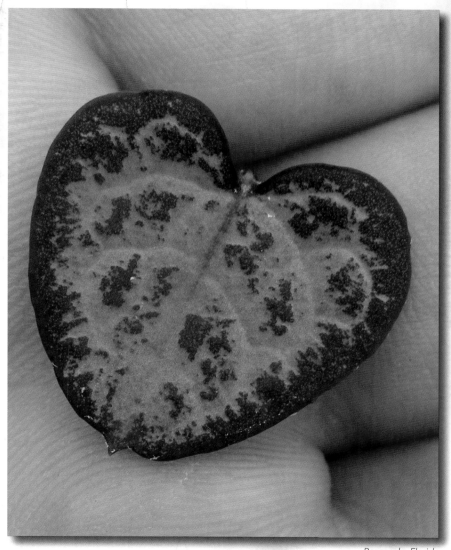

Pensacola, Florida

Love is

a canvas furnished

by Nature

and embroidered

by imagination.

VOLTAIRE

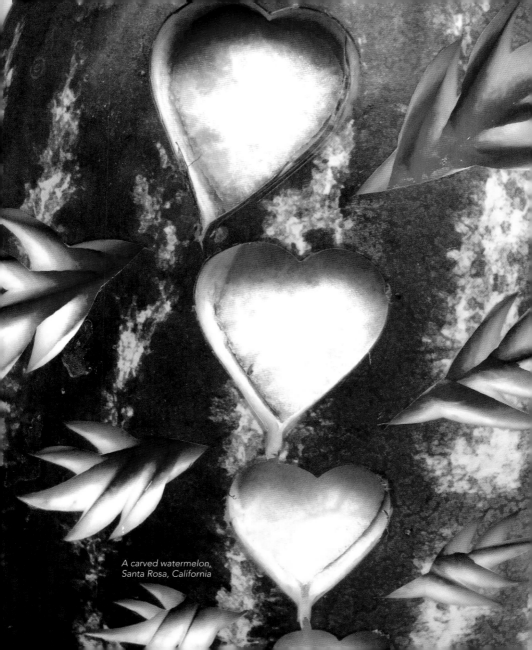

A carved watermelon,
Santa Rosa, California

I am fully and

intensely aware that

plants are conscious of love

and respond to it as

they do to nothing else.

CELIA THAXTER

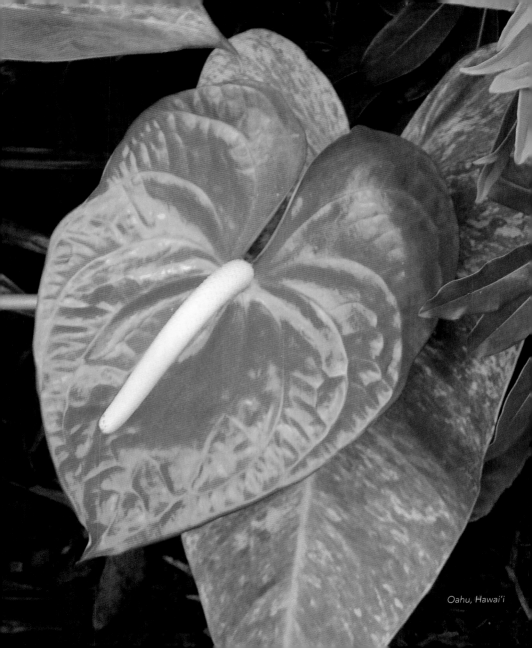

Oahu, Hawai'i

The love of gardening
may blind you to the
beauty of the garden.
Keep close to Nature's
heart... and break clear
away, once in awhile,
and climb a mountain or
spend a week in the woods.

Wash your spirit clean.

JOHN MUIR

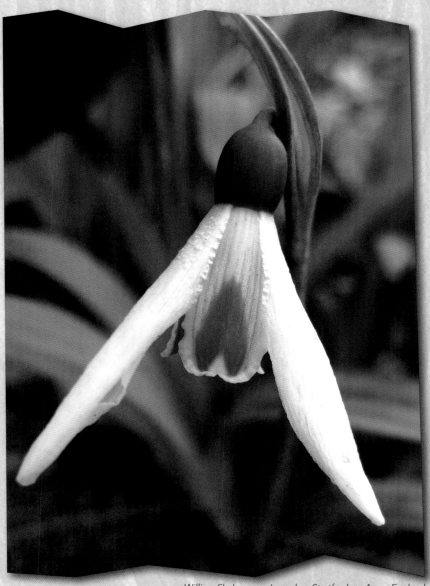

William Shakespeare's garden, Stratford-on-Avon, England

A kind heart is a
fountain of gladness,
making everything
in its vicinity
freshen into smiles.

WASHINGTON IRVING

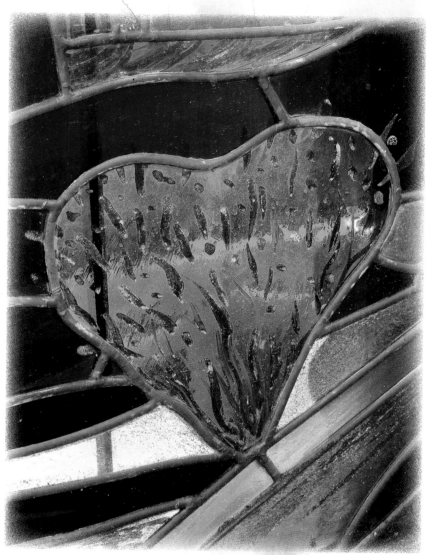

Elvis Presley's grave in Graceland, Memphis, Tennessee

I used to visit and revisit it

a dozen times a day,

and stand

in deep contemplation

over my vegetable progeny

with a love that nobody

could share or conceive of

who had never taken part

in the process of creation.

NATHANIEL HAWTHORNE

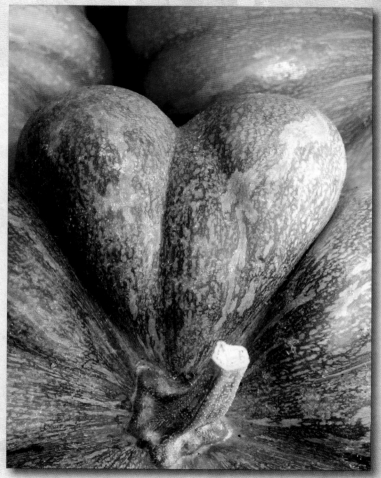

Farmers' Market in Richmond, Virginia

It used to be thought that
our love of plants was an
impractical but pure passion.

But now, in the age of
environmental crisis,
we're discovering that

GARDENING IS ESSENTIAL
TO HUMAN LIFE.

JACQUELINE HERITEAU

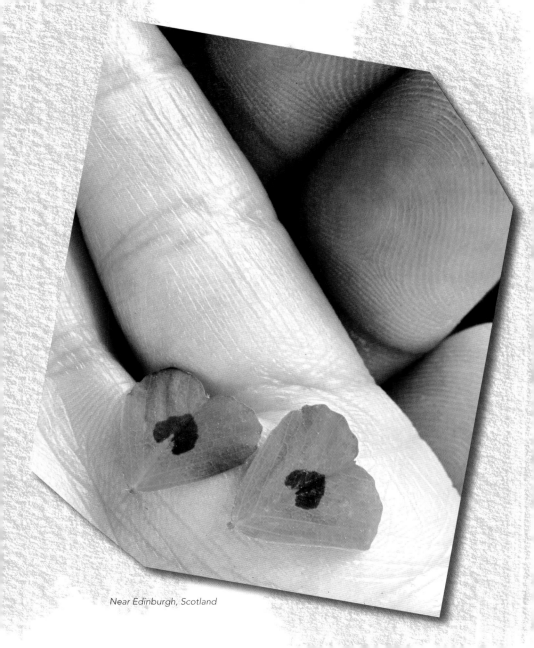

Near Edinburgh, Scotland

One can get lost in their garden

and the rest of the world ceases to exist,
if only for a while. Anger dissipates with
every shovel of dirt moved, pleasure is
found in the simplest forms, excitement
is felt as each tiny plant matures and
then triumph with the harvest of
the first tomato of the season.
The love of gardening never goes away.
Even if someone is unable to
garden themselves, they enjoy
the gardens of others.

RENEE HOGAN

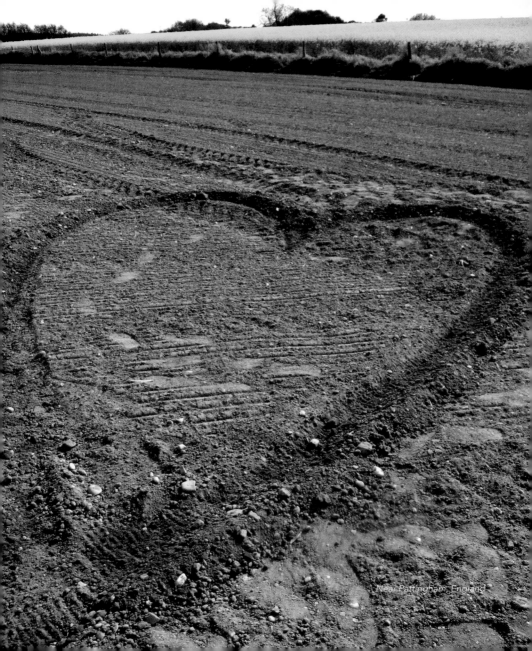

Near Pattingham, England

Plant on a whim.

Lay the footpath
where your heart
says it should be.

Change things

because you feel like it.

Garden for

the love of it.

LINDLEY KARSTENS

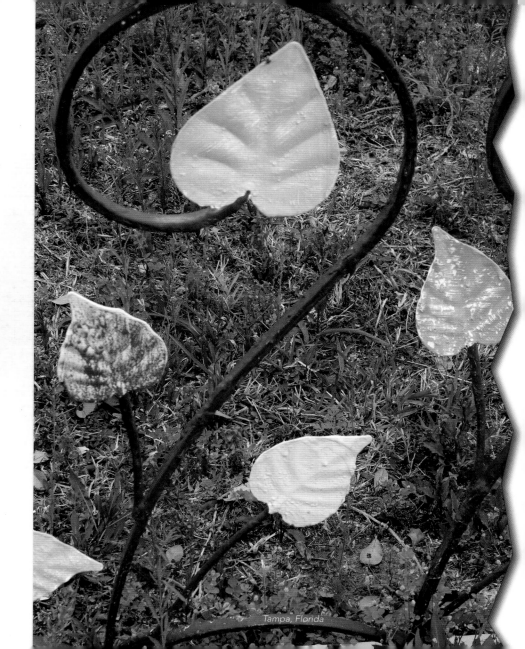

Tampa, Florida

Kind hearts are the gardens,
Kind thoughts are the roots,
Kind words are the flowers,
Kind deeds are the fruits,
Take care of your garden,
And keep out the weeds,
Fill it with sunshine,
Kind words and kind deeds.

HENRY WADSWORTH LONGFELLOW

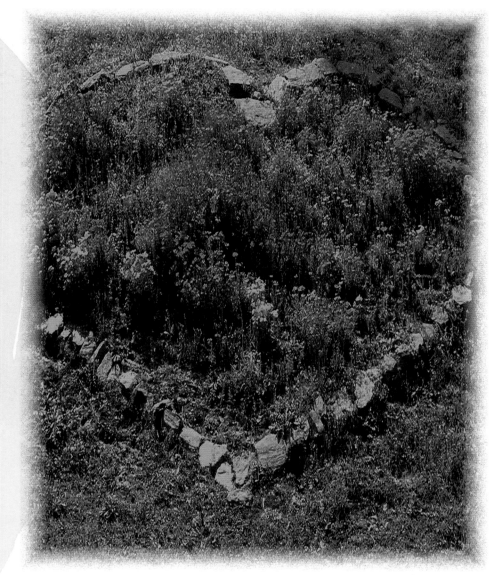

Near Athens, Georgia

gardening is a cooperative affair.

i am a part
of a neighborhood
in which plants, dirt,
rocks and a human family
participate collectively
in a love affair
with place.

JIM NOLLMAN

Architectural detail, Erie, Pennsylvania

It is curious, pathetic almost, how deeply seated in the human heart is the liking for gardens and gardening.

ALEXANDER SMITH

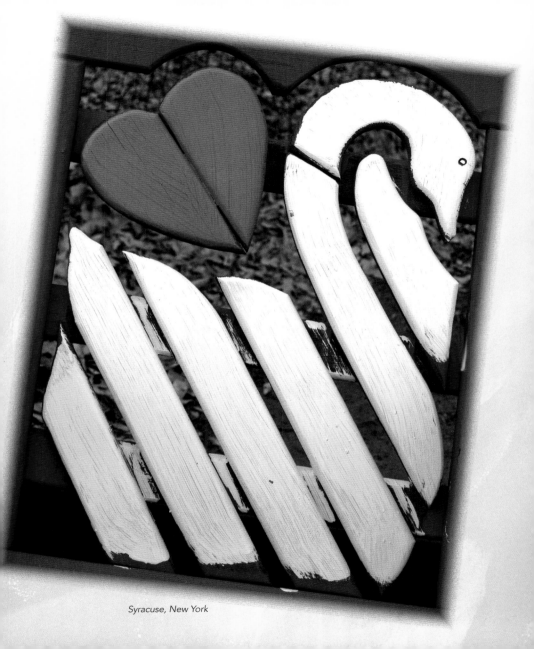

Syracuse, New York

OLD LOVE

DOES NOT RUST.

ESTONIAN PROVERB

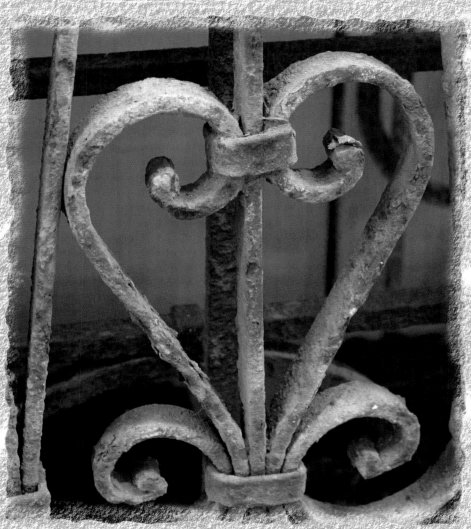

Isle of Man, middle of the Irish Sea

So WE GROW TOGETHER,

LIKE TO A DOUBLE CHERRY,

SEEMING PARTED,

BUT YET AN UNION IN PARTITION;

TWO LOVELY BERRIES

MOLDED ON ONE STEM;

SO, WITH TWO SEEMING BODIES,

BUT ONE HEART...

A MIDSUMMER NIGHT'S DREAM;
WILLIAM SHAKESPEARE

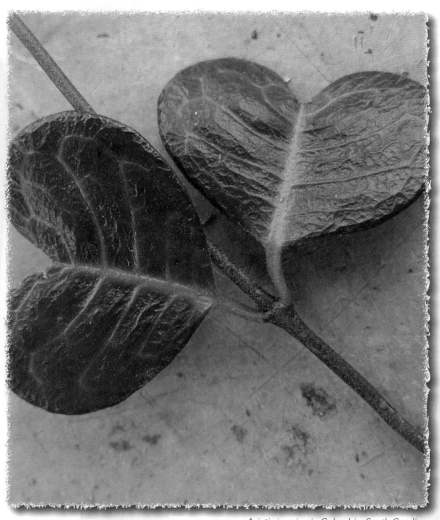

Asiatic jasmine in Columbia, South Carolina

Keep a green tree

in your heart and

Greenwood, Mississippi

perhaps the song bird will come.

CHINESE PROVERB

Love is much
like a wild rose,
beautiful and calm,
but willing to draw
blood in its defense.

MARK OVERBY

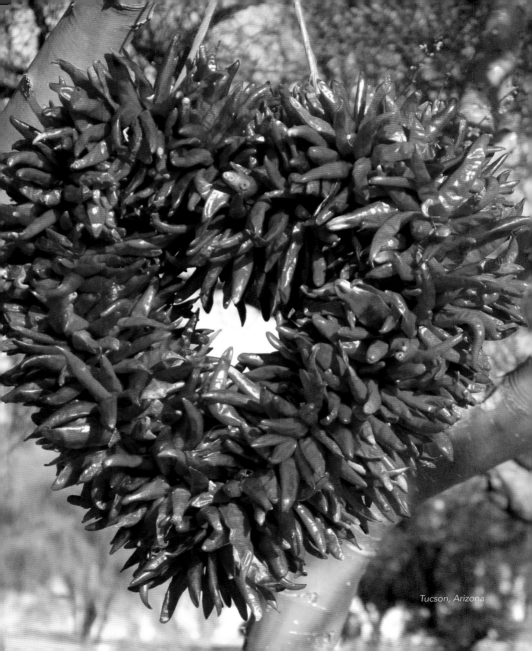

Tucson, Arizona

Memories are forget-me-nots
gathered along life's way,
pressed close to the human heart
into a perennial bouquet.

CLARA SMITH REBER

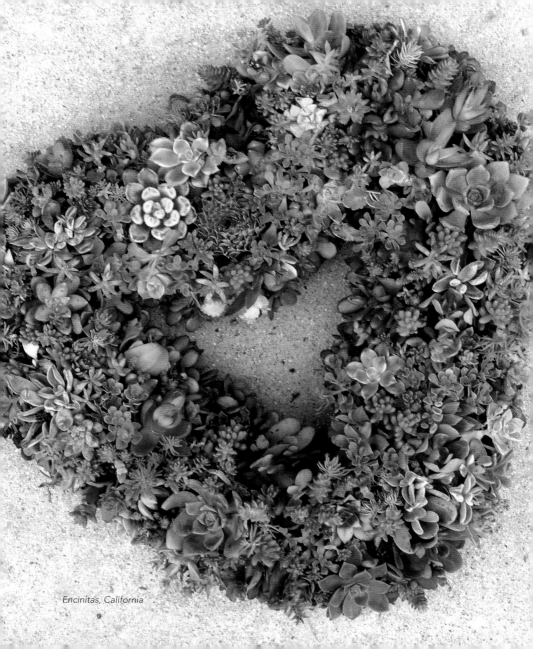
Encinitas, California

LET US BE GRATEFUL

TO PEOPLE WHO MAKE US HAPPY,
THEY ARE THE GARDENERS
WHO MAKE OUR SOULS BLOSSOM.

MARCEL PROUST

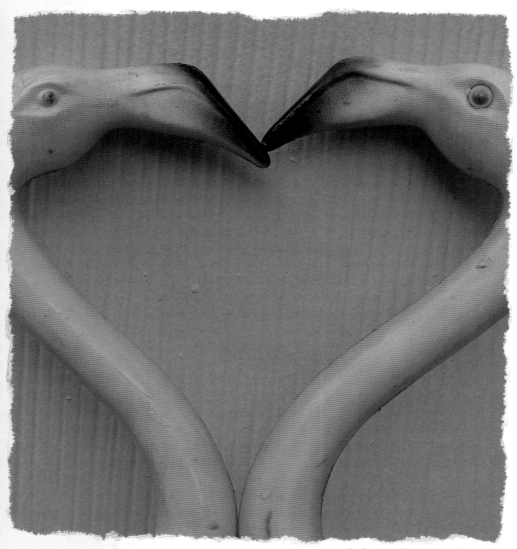

Author's garden, Jackson, Mississippi

The world is so empty if one thinks only of mountains, rivers, and cities; but to know someone here and there who thinks and feels with us and though distant, is close to us in spirit – this makes the earth for us an inhabited garden.

JOHANN VON GOETHE

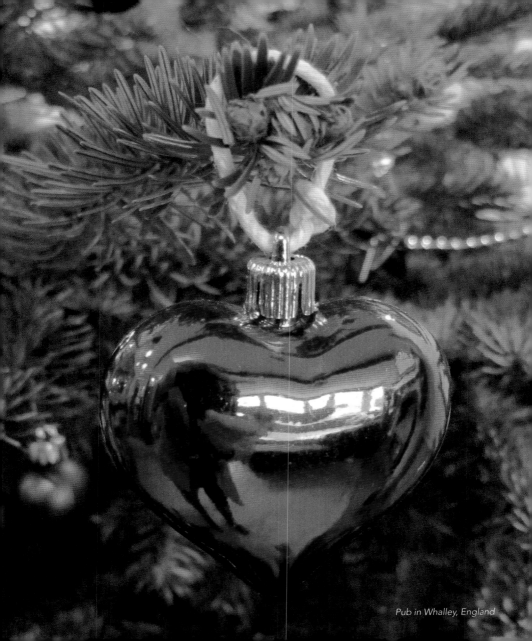

Pub in Whalley, England

A flower touches
everyone's heart.

GEORGIA O'KEEFE

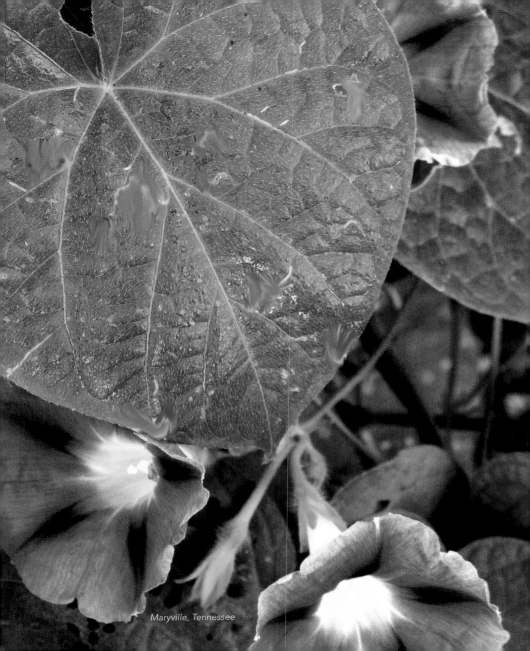

Maryville, Tennessee

Love is the flower

you've got to let grow.

JOHN LENNON

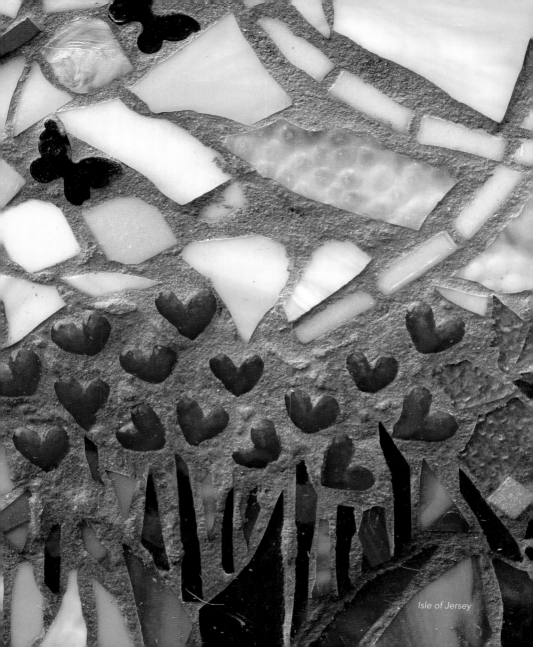

Isle of Jersey

Love is
the flower of life,
and blossoms
unexpectedly
and without law.

D. H. LAWRENCE

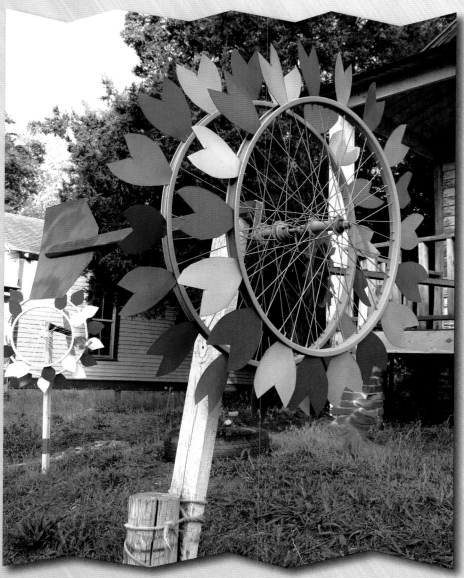

Near Macon, Georgia

Nevertheless, it means much

to have loved,

to have been happy,

to have laid my hand

on the living Garden,

even for one day.

JORGE LUIS BORGES

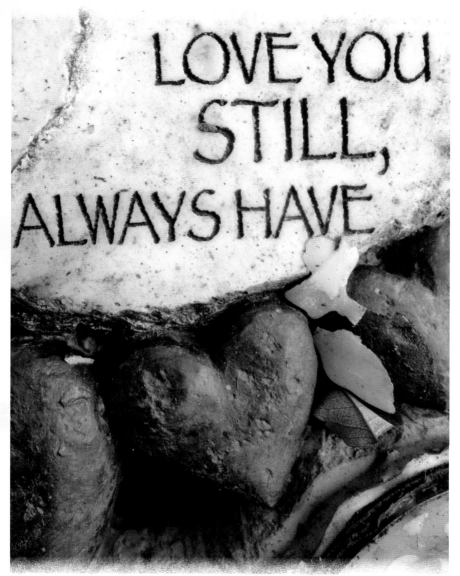

LOVE YOU STILL, ALWAYS HAVE

Cemetery in Pattingham, England

I came here
looking for peace
and understanding ,
but all I found was

LOVE.

FELDER RUSHING

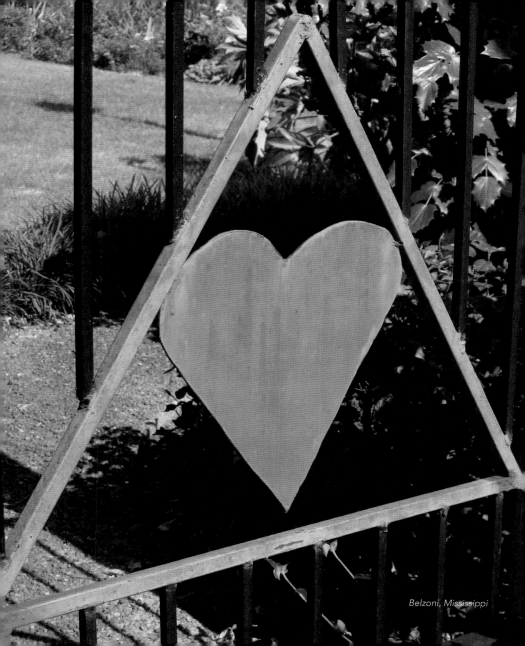

Belzoni, Mississippi

In the sweetness of friendship
let there be laughter,
and sharing of pleasures.
For in the dew of little things
the heart finds its morning
and is refreshed.

KHALIL GIBRAN

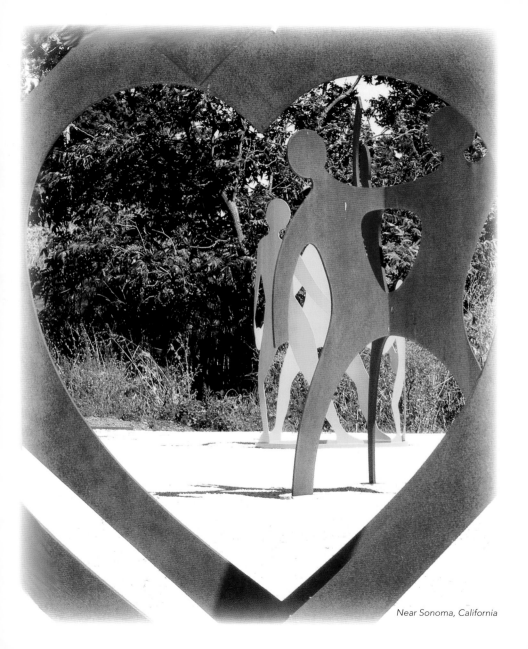

Near Sonoma, California

IF YOU WISH TO MAKE
ANYTHING GROW, YOU
MUST UNDERSTAND IT,
AND UNDERSTAND IT
IN A VERY REAL SENSE.
'GREEN FINGERS'
ARE A FACT, AND
A MYSTERY ONLY TO
THE UNPRACTICED.
BUT GREEN FINGERS
ARE THE EXTENSIONS OF
a verdant heart.

RUSSELL PAGE

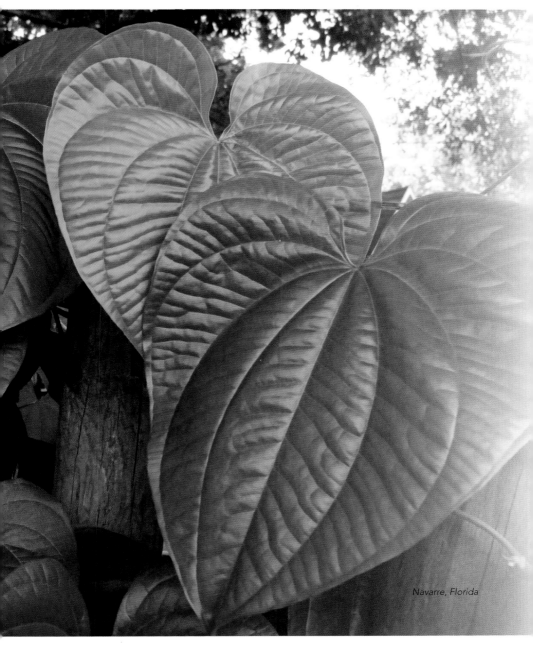
Navarre, Florida

It is utterly forbidden to be
half-hearted about gardening.
You have got to love your garden
whether you like it or not.

W.C. SELLAR & R.J. YEATMAN, IN *GARDEN RUBBISH*

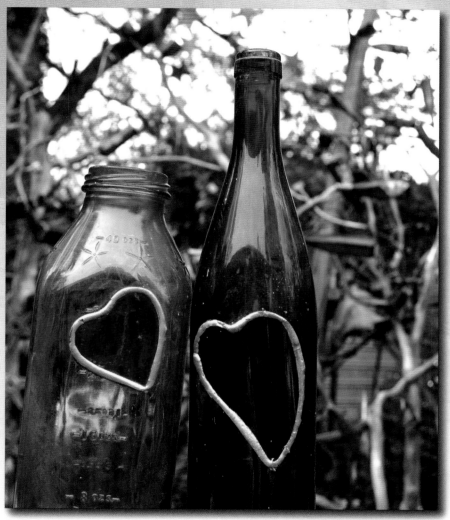

Bottles in "yard art" garden, Huntsville, Alabama

I knew in my heart that I wanted to know the garden intimately, to know all the flowers in each season, to be there from spring through autumn, digging, pruning, planting, feeding, rejoicing. In short, I had fallen in *love*.

ELIZABETH MURRAY

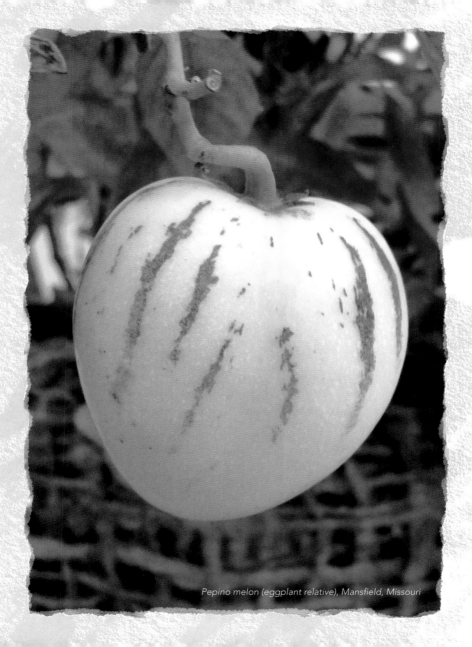

Pepino melon (eggplant relative), Mansfield, Missouri

Study nature,
love nature,
stay close to nature.
It will never fail you.

FRANK LLOYD WRIGHT

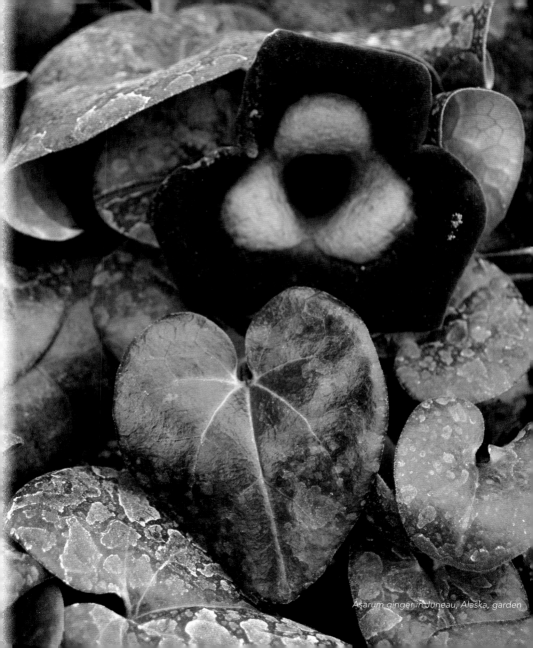

Asarum ginger in Juneau, Alaska, garden

The kiss of the sun for pardon,

The song of the birds for mirth,

One is nearer God's heart in a garden

Than anywhere else on earth.

DOROTHY FRANCES GURNEY, "GARDEN THOUGHTS"

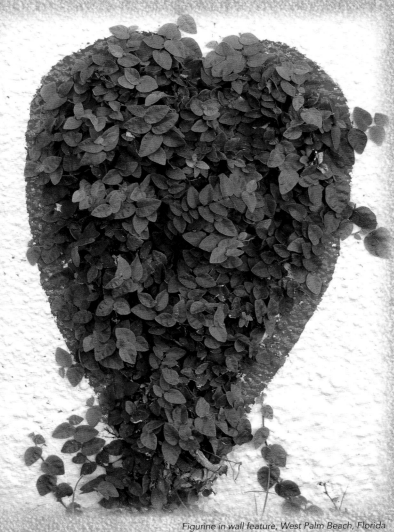

Figurine in wall feature, West Palm Beach, Florida

I have a garden of my own,

 Shining with flowers of every hue;

I loved it dearly while alone,

 But I shall love it more

with you.

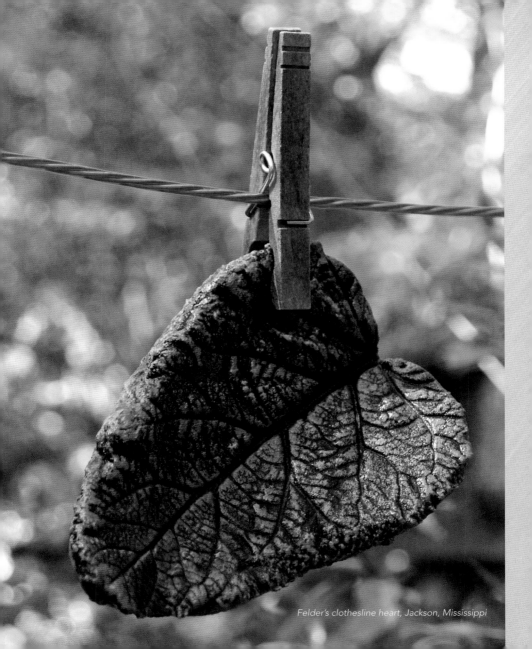

Felder's clothesline heart, Jackson, Mississippi

We are made for loving.

If we don't love,

we will be like plants

without water.

ARCHBISHOP DESMOND TUTU

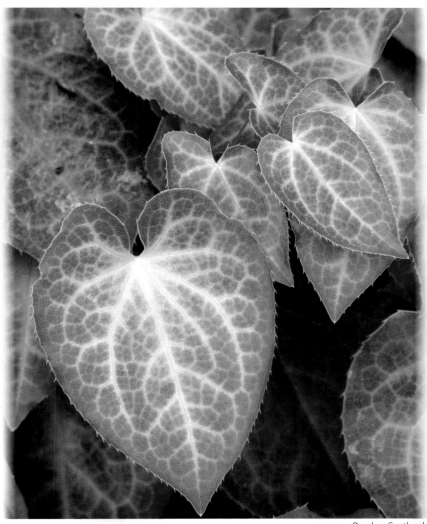

Rosslyn, Scotland

ABOUT FELDER RUSHING

*F*elder Rushing is a 10th-generation American gardener who putters about a celebrated cottage garden surrounding his Mississippi cabin. He lives part of the year on a rural Crown cottage farm in the western Midlands of England and travels extensively in the U.S. and around the world, lecturing and seeking out the subtleties of gardens done just for the love of it.

Felder has written newspaper gardening columns for over 30 years, and hosted or appeared in a number of TV garden programs. He has been featured three times in the *New York Times* for his laid-back "the rules stink" approach to gardening. The author of 17 gardening books and host of a popular NPR-affiliate radio program, he has had countless articles and photographs in gardening magazines, including *Fine Gardening, Horticulture, Garden Design, Organic Gardening, National Geographic* and *Better Homes & Gardens*.

His garden wisdom and often-irreverent observations can be found at www.felderrushing.net.